The Black Presence

All the paintings illustrated in this booklet are from the collection of the Walker Art Gallery, except the *Portrait of Catherine Marie-Legendre* by JB Santerre and *Jim Crow* by William Henry Hunt, both of which are from the Lady Lever Art Gallery, Port Sunlight. *The Black Boy* is normally displayed at the Merseyside Maritime Museum.

I am grateful to the many people who read drafts and made valuable comments that have been incorporated into the text. I would particularly like to thank Frank Milner who initiated this project and acted as editor.

Miranda Stacey
February 1999

Book production by
The Bluecoat Press
Bluecoat Chambers
School Lane
Liverpool L1 3BX

Book design by
March Design, Liverpool

ISBN 1 902700 04 X

Funds from the JP Jacobs Charitable Trust have made it possible to donate copies of this publication to the libraries of all Merseyside secondary schools and colleges.

The Black Presence

The Representation of Black People in the Paintings
of National Museums and Galleries on Merseyside

Miranda Stacey

■ NATIONAL MUSEUMS &
GALLERIES ON MERSEYSIDE

NMGM

NATIONAL MUSEUMS &
GALLERIES ON MERSEYSIDE ■

Introduction

The Walker Art Gallery's collection includes a group of paintings in which black people are represented or which are strongly associated with black history. This booklet examines these works which span the period from 1520 to1940. (The designation Black is here used to cover ethnic, cultural or religious groups that are principally of African or Asian origin.) Some images are intimately connected with the history of slave-trading which played such a major part in Liverpool's 18th century economy. Some are linked more generally with maritime history, a few are religious paintings, others are illustrative of 19th century colonial values. In an introductory survey such as this it is not possible to present an in-depth analysis of the black presence in Europe over the five centuries in which these works have been produced. However it is hoped that this booklet might be a starting point for both students and the general reader, providing a stimulus for future enquiry.

There is one man who stands out as an important figure not only in the history of the Walker Art Gallery but also as a major opponent of Liverpool's trade in human lives. William Roscoe (1753-1831) was an attorney, banker, Radical Whig politician, penal reformer, poet, literary historian, botanist and learned dilettante as well as a committed abolitionist. In 1788 he was one of a small group of Liverpool reformers who founded a local branch of the Anti-Slavery Society. In addition, during his brief period as a Member of Parliament for Liverpool, Roscoe participated in the vote in the House of Commons which outlawed the transporting of slaves on British vessels. Roscoe is shown seated in his study surrounded by objects that indicate his literary, political and artistic interests. The marble bust on his table is of Charles James Fox, a Radical politician whom he admired. Roscoe collected many of the Old Master paintings and drawings, which now

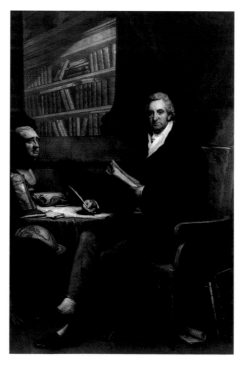

form a substantial part of the Walker Art Gallery's collections. Slavery, he believed, was the very antithesis of art, culture and learning, leading as it did to the destruction of human potential for intellectual greatness. Roscoe hoped that Liverpool might flourish - like a great Renaissance city - and he dedicated much of his life to the advance of beauty, culture and freedom.

If Roscoe is representative of an unusually humanitarian side of 18th century and early 19th century Liverpool then Richard Gildart, portrayed here by Joseph Wright of Derby in 1768, is an example of the port's deep involvement in slave-trading. Gildart was three times Mayor of Liverpool and a Member of Parliament from 1734 to 1754.

William Roscoe, by Martin Archer Shee, painted in 1822

With his sons he owned at least three slaving vessels. For over fifty years slave-trading merchants like Gildart dominated the social and political life of Liverpool. With the brief exception of Roscoe's tenure as a Member of Parliament in 1806-7, all Liverpool MP's of the 18th and early 19th centuries were either slave traders in their own right or defenders of the trade in parliament. Liverpool was both the economic and political capital of the English slave trade. In contrast to the portrait of Roscoe, man of letters, Wright portrays Gildart as a stern-faced and shrewd businessman, staring straight at the viewer.

The portrayal of black people in European art is very varied. In paintings from the 15th to the 18th century they are commonly shown as servants or as slaves, frequently exotically dressed and included as a kind of fashionable accessory signifying the wealth and status of their master or mistress. In grander pictorial or sculptural schemes (in for example civic buildings or palaces) black people appear as personifications of particular places - typically of Africa, America or the Indies. Black people also appeared occasionally in religious paintings. The black St Maurice is a departure from the usual conventions of pale-skinned sainthood but the black Magi - one of the three kings who visited the Christ Child at Bethlehem - is perhaps the most frequently occurring black individual in holy pictures.

During the 18th century, theories developed about the possibility of society being run on simpler, more 'natural' lines and this led certain thinkers to view aspects of black African and Asian society as somehow preferable to the overcivilized decadence of European life. The ideal of a return to nature and the notion of the free-spirited 'Noble Savage' gained currency and contributed to the developing abolitionist case. Paintings, novels, plays and poems were produced that introduced a more powerful, positive, albeit at times, romanticised image of black people. However, despite this, several philanthropists continued to view Africans as essentially children who were oppressed by slavery and its consequences. They believed that the civilising influence of Europeans was required in order for them to obtain salvation and social improvement. Colonial rule during the 19th century was underpinned by such white suprematist notions. The art and literature which was inspired by such thinking is often regarded nowadays as both sentimental and patronising.

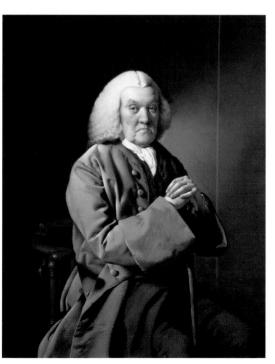

Richard Gildart, by Joseph Wright of Derby, painted in 1768

Portrait of a Young Man, by Jan Mostaert, painted about 1520.
Mostaert was a Dutch artist who worked principally as a portrait
painter for the aristocracy at the court of Margaret of Austria,
Governor of the Netherlands and daughter of the Emperor
Maximilian.

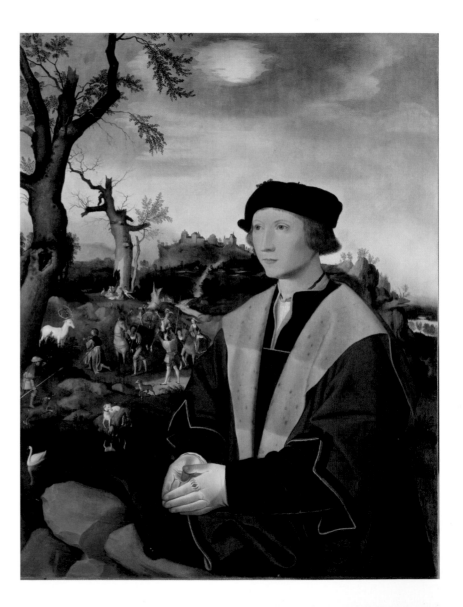

The Court Servant

Portrait of a Young Man by Jan Mostaert, painted about 1520

Painted in about 1520 by the Dutch artist Jan Mostaert, this is the earliest picture in the Walker's collection to illustrate the presence of black people in Europe. In the scene behind the portrait of the young man there is a black groom holding a horse amongst a richly dressed hunting party. The scene depicted is from the legend of St Hubert. This relates how St Hubert whilst on a hunting trip on Good Friday saw a vision of a stag with a crucifix between its horns and was converted to Christianity.

Although the Portuguese had been importing black Africans into Europe since the 15th century, it was the discovery of the New World which greatly increased their use for slave labour. The trade in slaves into Europe, however, never reached great numbers and black people enslaved in Europe were generally regarded as luxuries, rarely to be used for hard labour. As such they were increasingly shown in art as servants, grooms, pages and musicians. In Northern Europe black slaves would have been seen almost exclusively at court or in aristocratic circles. In this painting, the presence of the black groom symbolises the wealth and status of all those portrayed in this aristocratic and courtly setting. Slaves in Europe were normally converted to Christianity by their masters. The black servant dressed in European clothing is the figure standing closest to St Hubert. This suggests the successful shaping of other cultures according to the European Christian model. We don't know who the young man is that is portrayed in the foreground. He appears to be wearing a uniform of some kind - possibly that of a lay religious fraternity dedicated to St Hubert.

A number of other paintings by Mostaert feature black figures. These include his *West Indies Landscape* which depicts the expedition made by Coronado to Arizona and New Mexico in 1540-42, an *Adoration of the Magi,* (both now in the Rijksmuseum, Amsterdam) and his *Portrait of a Moor* (on loan from a private collection to Kenwood House in London). Despite his fascination with New World and African subjects, Mostaert almost certainly never travelled outside Europe and would have principally come into contact with black people through his work as portrait painter to the Burgundian court.

Dressed in fine livery probably made of rich silks the black groom is an exotic accompaniment to this aristocratic hunting party.

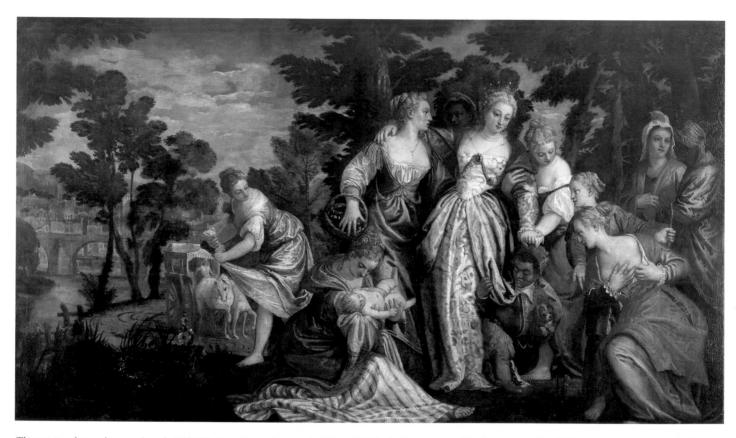

This painting depicts the scene from the Bible (Exodus, Chapter2, verses 1-10) in which Pharhoe's daughter and her handmaidens found Moses in the river Nile. The elaborate dress and setting of the picture reflect 16th-century high society. The three black attendants were included as exotic and picturesque fashionable accessories to signify the social standing of the princess at the centre of attention.

The Court Servant

The Finding of Moses from the Studio of Paolo Veronese, painted about 1582

This painting from the Venetian workshop of Paolo Veronese (1528-88) is a testament to the importance of the black presence in 16th century Venice. Slavery had existed in Italy from ancient times largely due to Italy's geographic location and role in world trade. The Venetians were a seagoing nation and their links with North Africa, Spain, the Byzantine and Moslem East played an important part in shaping the cosmopolitan make-up of Venetian society. Until the 15th century, Venetian slave traders dealt mainly in white slaves from the Black Sea region. However after this area was closed off as a result of the Ottoman conquest of Constantinople, black slaves from Africa were in demand. The ports of Pisa, Genoa and Venice were the principal entry points for these black slaves arriving from Africa.

Although this is a subject from the Bible, the costumes are those of 16th century Venice. Veronese suggests an exotic non-western setting for this incident, which actually took place on the banks of the Nile, by including two black ladies-in-waiting and a black dwarf. (Veronese was well-known for his lack of concern for historical accuracy. Famously on one occasion he had to appear before the Inquisition in order to justify certain irreverent things he had put into a painting of the Marriage Feast at Cana). What we see in this picture is in fact an elaborately-staged courtly picnic in the countryside of Northern Italy.

The black serving-woman to whom confidential errands were entrusted and who was both companion and accomplice to her mistress was a widely known figure in the Mediterranean world. Slaves in Venice, as in Northern Europe, were invariably domestic and were not used in agriculture as they were in the New World. There is evidence that some black oarsmen were used on Venetian war galleys but more usually they might be employed as gondoliers in the service of one master.

Dwarves were a feature of several 16th and 17th century courts and were often regarded rather like human pets. The Duke of Mantua had a special suite of small rooms to house his group. Philip IV of Spain got his court painter Velazquez to paint a magnificent series of portraits of his favourite dwarves.

Veronese's interest in rich colour effects raises questions about the extent to which he may have regarded the painting of black-skinned figures as offering interesting pictorial possibilities - using them as an aesthetic device to give added complexity to his works. That certainly seems to have been the view of John Ruskin, the famous 19th century art critic who wrote in 1858 'I always think the main purpose for which negroes must have been made was to be painted by Van Dyck and Veronese'. Pale white skin was often regarded as being the mark of beauty during the 16th century and thick white make-up was put on to emphasise whiteness. Black people were sometimes included by artists in their pictures to provide a contrast that was intended to confirm this Western canon of perfect pale beauty.

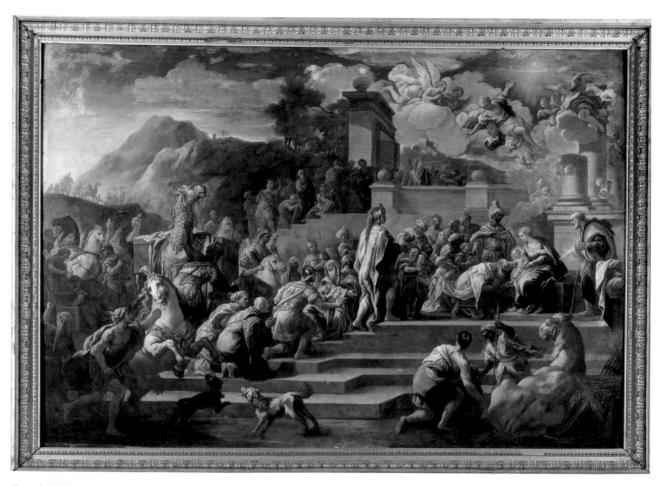

From the 12th century onwards, the theme of the black King became very popular in Western art. Here we can see, not only the splendidly dressed black king Balthazar, but also numerous other black figures who have accompanied him. Painted in Naples at the beginning of the 18th century, the artist would have been familiar with black people who had been arriving in the port as slaves for centuries.

The Black King

Adoration of the Magi by an unknown Neapolitan artist of the 18th century

One of the earliest subjects in Western art to include black figures was that of the Adoration of the Magi. The Magi were kings from the east who had followed a star seeking the King of the Jews - the infant Christ. Traditionally in Western art, a black figure had represented the devil, hell or death. From the 12th century onwards Balthazar - one of the Magi - began to be depicted as black. Previously Balthazar had been depicted as pale-skinned (a famous example is the 6th century mosaic that can be seen in the church of S Appolinare Nuovo in Ravenna). The reason for the change was that from about 1100AD the three kings became associated with the themes of the 'three ages of life' and the 'three parts of the known world' - Europe, Africa and Asia. Balthazar, representing Africa is instantly recognisable standing next to the Virgin in this painting.

The black King in Medieval and Renaissance art is thus invariably shown as a dignified, regal figure, splendidly dressed and bearing rich gifts. Here, he stands proud and upright beside Mary, in stark contrast to the elderly kneeling King. There are a number of black attendants among the Kings' retinue, along with the camels, symbols of the exotic East. The frequent appearance of the black King in paintings of the Adoration of the Magi from the second half of the 15th century and through to the first half of the next century coincided with the expansion of Europe, the missionary expeditions to Africa and the beginnings of the slave trade. In this scene, a splendidly dressed black ruler comes to the white man and lays down his wealth and his power at the feet of Christ, the founder of Christianity. In reality however, from the 16th century, missionaries and slavers seized the black man's property, plundered his wealth and subjugated his people by force.

From the 18th century onwards, the image of the dignified black King attending the Virgin was debased by some artists into the image of the black slave-servant attending the secular White Mistress in an attitude of inferiority and humiliation.

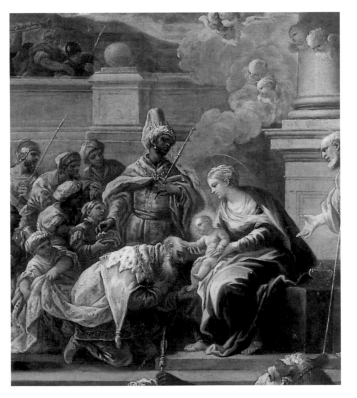

The exotically dressed King Balthazar, representing the continent of Africa.

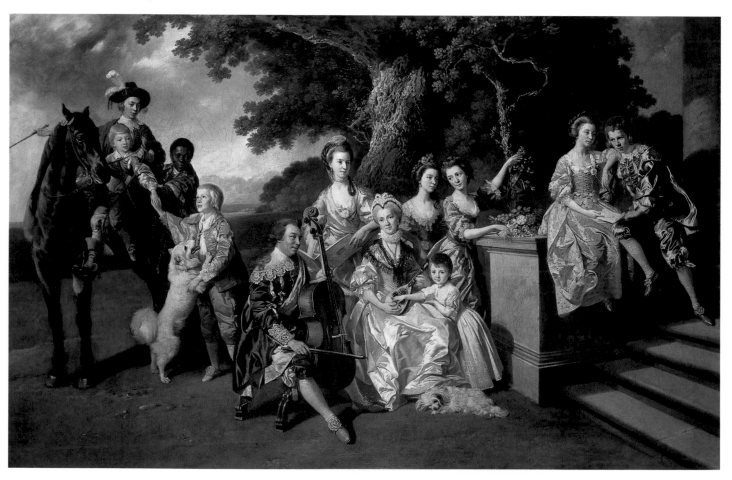

Because of their rarity, exotic nature and curiosity value, black slave-domestics began to figure predominantly in more and more prosperous households and, as a particularly popular feature of 18th-century portraiture, they served in art as in life as accessories reflecting the status, elegance and wealth of their owners.

Domestic Slaves in 18th Century Portraiture

The Family of Sir William Young by Johan Zoffany, painted about 1770

This group portrait, by Johan Zoffany shows The Family of Sir William Young, owner of sugar plantations in the West Indies and Governor of Dominica from 1770 to 1774. It reflects the popularity of black domestic slaves among the rich in 18th century England. Between 1700 and 1800, about 11,000 ships left Britain (one half of them from Liverpool, the rest mainly from Bristol and Glasgow), for the 'triangular trade' to Africa and thence to the Americas. Given the vast numbers involved, it was inevitable that some black people would find their way to Britain. There had been black servants in England since the 16th century, although these were few in number. For some years, English law wrestled with the legal, moral and social problems created by the increasing movement of slaves from the Americas to Britain. In 1749, the Lord Chancellor, Lord Hardwicke, confirmed the ruling that slavery was legally sanctioned in England.

Before the opening up of Jamaica in the later 17th century, the development of Barbados was the greatest single stimulant to the growth of the English slave trade. To feed the burgeoning sugar industry thousands of African slaves were deposited on the island. Overwhelmingly the slaves who came to Britain were the human property of homecoming Englishmen, plantation owners and officials. This painting appears to be set in England rather than the West Indies. It may have been commissioned in connection with the marriage in 1770 of the woman standing in the centre of the picture. All the figures are wearing so-called Van Dyck costume - satin and silk clothes that would in reality have been worn a century earlier. It was fashionable during the 1760s and 1770s to be portrayed wearing such clothes. It is possible that the black youth steadying one of the boys on horseback was a slave who had accompanied Young back to England. He is certainly a portrait. As in other paintings that include black servants, he wears an exotic and expensive earring and highly decorative livery. He does not however wear a metal collar which was sometimes worn as a sign of chattel status. This, together with the familiar way in which he steadies the boy on horseback, suggests that he may have been regarded by the family as more of a servant than a slave. Sir William died on the island of St Vincent in 1788, on a visit to his West Indian estates and in his will there are several references to his slaves. A few he freed, others he bequeathed and he stated '... give to the Negroes on each of my plantations ten bands of good earrings and a holiday to work in their grounds ...' Although he does name several of his slaves in his will, it is impossible to identify the particular youth in this painting.

From the mid-century onwards there was a growing tide of opposition to slavery which resulted in modifications to the law. On 22 June 1772, Lord Mansfield pronounced what has become known as the 'Mansfield Judgement'. Mansfield said that a master could not by force compel a slave to go out of England. This was a significant victory for the humanitarians and it meant that black slaves brought into England could not be returned to the horrors of plantation life. Painted in about 1770, the artist's sympathetic portrayal of the black youth may be a reflection of the changes which were just beginning to take place.

Portrait of Catherine-Marie Legendre by JB Santerre, painted about 1705

It seems she hangs upon the cheek of night like a rich jewel in an Ethiope's ear.
Shakespeare, *Romeo and Juliet*, I, iv.

In 18th century portraiture slave boys were often shown being petted condescendingly by their mistresses. This portrait of the French noblewoman Catherine-Marie Legendre is typical. The black page's dark skin is used to set off her fair complexion. He is a rather anonymous and impersonal figure and his presence is purely decorative. He is unlikely to be a true portrait. Here he is depicted carrying a plate of fruit towards which his mistress points - suggesting the wide range of produce yielded up by the West Indies from where he came. A sense of his status as 'non-human property', a mere purchasable commodity, is indicated by the 'slave collar' worn around the neck and usually inscribed with the name of the owner.

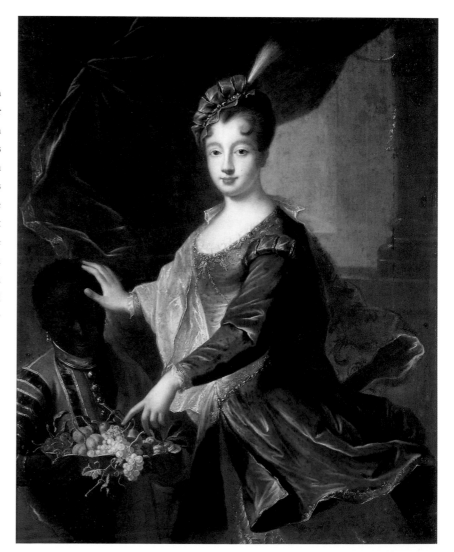

The Card Party after Gawen Hamilton painted about 1725 or 1737

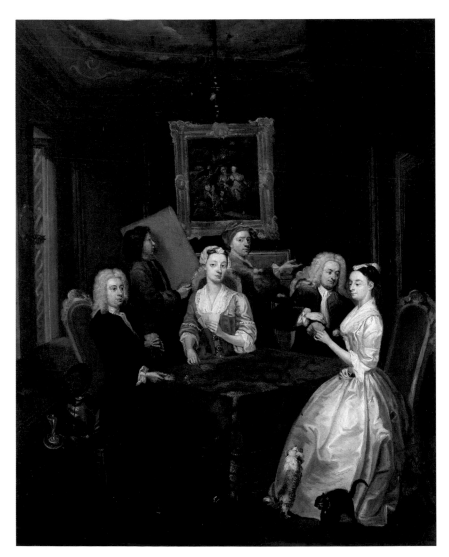

This type of group portrait, small in scale and with several figures, is called a 'conversation piece' because of the implied discussion that might be taking place between the people portrayed. It shows a fashionable room somewhere in London with a group of prosperous society people playing cards. In the background an artist and a servant are carrying various objects. The figures in the picture include the artist Dietrich André, possibly his newly-wed English wife, the artist Sir James Thornhill (for whom Andre worked) together with Mrs Thornhill.

A black page boy is seen leaving the scene in the left foreground. He appears to be about eight years old and like the boy in the picture by Santerre, he in wearing exotic livery and a slave collar. It was usual to purchase slave boys when they were two to three years old and to start them working at about the age of five. Looking at this little picture one might perhaps reflect on the loneliness and isolation that such young black pages might have experienced in such households.

Black Sailors

The Death of Nelson by Daniel Maclise painted between 1859 and 1864

During the 18th century the black presence in Britain greatly increased. Apart from servant slaves already discussed, there were many free sailors who made only brief visits into port before heading back to sea. Given the nature and destination of a substantial part of England's maritime trade, it was inevitable that Africans, both freemen and slaves, would find employment on English naval and merchant ships and would spend time in ports like Liverpool, Bristol and London.

Daniel Maclise included black sailors in his Death of Nelson because there was evidence of black men having been on board HMS Victory. The incident depicted is the moment of Nelson's fatal injury aboard the quarter deck. It is an imaginary reconstruction, clearly too crowded for a real battle, but done with enormous attention to detail. This picture is a replica of Maclise's very large wall painting in the Houses of Parliament. Over 50 years after the Battle of Trafalgar,

Maclise's researches included speaking to the few aged survivors, going through naval records and carefully recording old cannons, knots and other equipment.

There are two black sailors in this painting; on the left a ship's cook is bringing a glass of rum or brandy to a wounded man and further to the right, a seaman is pointing towards the French ship *Redoubtable*, from the rigging of which the fatal bullet had been fired at Nelson. Here the black sailor is given a central dramatic role as the pointing figure. His skin colour helps him to stand out from the crowd. Most black sailors would have been employed among the lower ranks of the ship's company, as either cook, deckhand or cabin boy, sometimes as stewards and occasionally as able seamen.

Although black sailors were rarely specifically identified amongst ships records, the Victory Master book of 1805 stated that 'the ships company were from every country in the British Isles and there is a

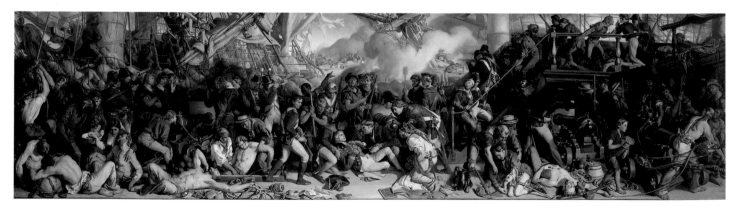

This painting depicts the death of Admiral Lord Nelson at the Battle of Trafalgar which took place on 21 October 1805 and in which the British Navy decisively defeated the combined French and Spanish fleets, making it the most successful naval engagement of the Napoleonic Wars. As a popular national hero, Nelson's death prompted numerous pictures and it was a fitting subject for the immense mural painting by Maclise that can still be seen in the corridor of the House of Lords.

scattering of foreigners. There is (sic) 23 giving America as their birthplace, some of whom must have been Negroes… Two give Africa as a birthplace.' It is likely that Maclise would have consulted this book and this is probably why he included the two black figures. He also showed women in the picture, despite their not being officially recorded as part of the ship's company and despite denials by the Admiralty that there were any on board.

White sailors do not appear on the whole to have resented their black co-workers. Life at sea was based upon a meritocractic system and in theory black seamen could live and work on equal terms with whites.

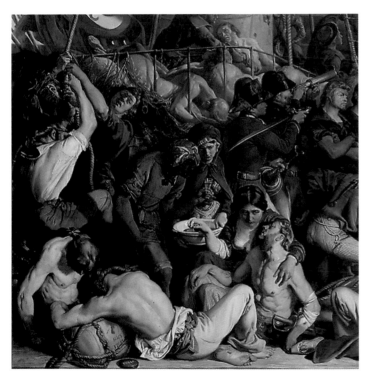

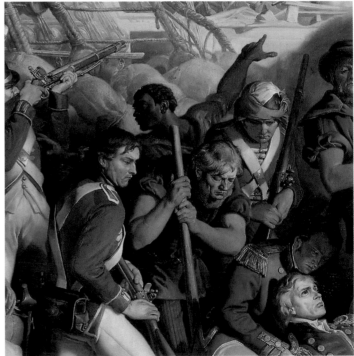

The Church of Saint Nicholas by WG Herdman, painted in 1842

During the 1840s Liverpool was a boom city full of ships and sailors from all over the world. Many non-European sailors were employed on British ships. Discriminatory wage rates operated and it was usual for black people from Africa and the West Indies to be paid more than those from India or the Far East. This practice was encouraged by the 1823 amendment that was made to the Navigation Act that stipulated that black sailors were to be 'as much British seamen as a white man would be' but which also stated that lascars were not to be regarded as British sailors. The term 'lascar' originally came into common usage to denote Indian seamen, but by the mid-19th century it embraced Burmese, Bengali, Malay, Chinese, Siamese, and Durati. Like the term 'coolie', lascar denoted both race and occupational status, and in the mouths of the British was invariably pejorative.

Herdman, who specialised in topographical views of Liverpool, shows in this picture of the Church of Saint Nicholas, two lascars from India in exotic dress walking along the quayside of the River Mersey amidst the bustle of people moving goods. A small group of foreign seamen with their distinctive and colourful clothing form an interesting focal point in the centre of this painting.

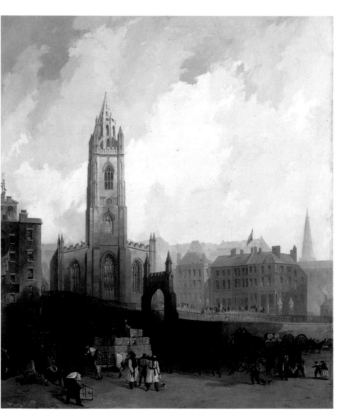

Sweethearts and Wives by John J Lee, painted in 1860

This picture shows the Liverpool quayside with sailors parting from their families and friends to take up their duties on board HMS *Majestic* anchored in mid-river. The face of an Asian sailor who is wearing naval uniform can be seen in the centre below the arms of the embracing couple. Black seamen became a more common sight in Liverpool as the 19th century progressed and the inclusion of this sailor in the painting accurately reflects the cosmopolitan nature of the city's seafaring community. Herman Melville, describing Liverpool in his novel *Redburn*, first published in 1849 wrote:

"In Liverpool indeed the negro steps with a prouder pace, and lifts his head like a man; for here, no such exaggerated feeling exists in respect to him, as in America. Three or four times I encountered our black steward, dressed very handsomely, and walking arm in arm with a good-looking English woman. In New York, such a couple

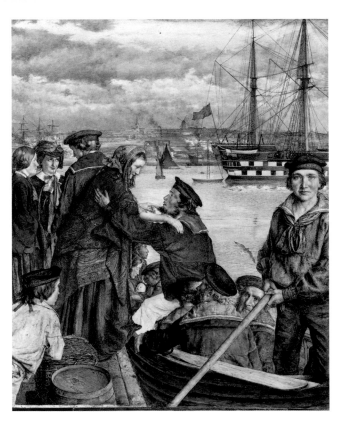

would have been mobbed in three minutes; ... Owing to the friendly reception extended to them, and the unwonted immunities they enjoy in Liverpool, the Black cooks and stewards of American ships are very much attached to the place and like to make voyages to it."

A number of shipping firms as a result of their trade connections with the East attracted Asian and African crew members; for example the company of Thomas and John Brocklebank who traded with Calcutta and, from 1834, after the end of the East India Company monopoly, also with China. This led to a greater presence of Asian and Indian sailors in Liverpool. As the port's trade continued to expand, particularly with West Africa, the West Indies and the United States, there was a steady growth of newly-arrived black people who formed distinct settled communities in the city.

Victorian Sentiment

Jim Crow by William Henry Hunt, painted in 1837

This watercolour was painted as one of a series, forming a pair with another picture of a black child entitled Miss Jemima Crow (1839). In a lithographic print that was made after the watercolour, it was given an obviously comic title: *Master James Crow - Out of his Element.* Hunt painted what he saw as an essentially humourous sentimental subject that was calculated to be popular with middle-class audiences and potential purchasers. The name 'Jim Crow' was originally used in an early 18th century music hall minstrel act which was performed in the United States and England by Jim Rice. Such acts typically had white performers impersonating black people. Originating in the late 18th century they became widespread during the following century. Later, the term 'Jim Crow' became a household word and the segregation laws - introduced in the Southern United States in the late 19th century became known as 'Jim Crow' laws.

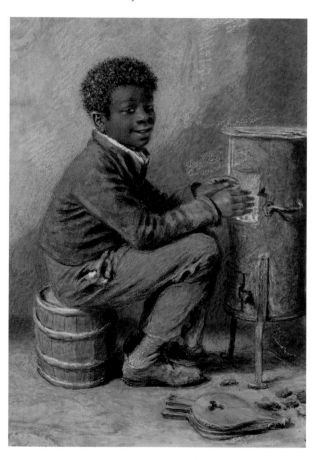

William Henry Hunt lived throughout his early life in the St Giles area of London, the home of various ethnic groups, many of them Blacks who might have served as his models. It seems likely that this picture is a genuine portrait rather than a blacked-up white person. The rather forced humour of the boy warming himself at a stove suggests that he is both out of his element (the sun) in a European or North American climate as well as being culturally separate.

The Black Boy by William Windus, painted about 1844

At one level this painting of a poor boy may be regarded as an example of the way European artists at times treated black people as picturesque subject-matter - at another it is a straightforward realistic portrait. Windus was born in Liverpool and trained as an artist at the Liverpool Academy Schools. This boy dressed in rags has traditionally been associated with a touching story. He is said to have crossed the Atlantic as a stowaway and been discovered by Windus on the doorstep of the Monument Hotel in Liverpool. Windus is then supposed to have employed him as an errand boy. The picture was apparently put in the window of a frame-maker's Liverpool shop where it was seen by a sailor relative of the boy who searched him out and eventually took him back to his parents - a suitably happy ending. Whether this anecdote is true or not is not certain.

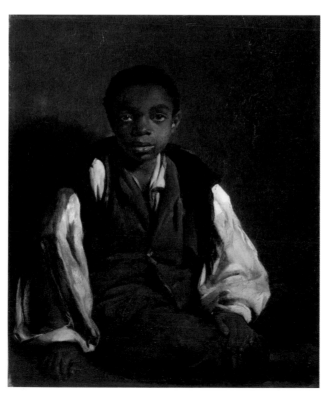

Before the American Civil War, black Americans in particular found the prospect of living in England tempting. It was a potential haven where their freedom was guaranteed and where they could move in a less hostile atmosphere. However, on arrival in England, stowaways who had managed to escape were often forced onto the streets. English attitudes towards the Black in the mid-century ranged from egalitarian friendship to open racist hatred. However, those who fled to England publicly testified to the improvement in their condition and there never was a time throughout the 19th century, when Liverpool did not have a black population.

Windus's image is one of picturesque poverty of a type that exerted a strong and ambivalent appeal in Victorian England. Importantly it is also a strikingly forthright picture of a boy, shown in a matter-of-fact pose without any accompanying humourous props or symbolic details to suggest lowly status or social inferiority.

Windus was the most important of the Liverpool Pre-Raphaelite artists and had a developed social conscience. Another picture by him in the Walker's collection, *Burd Helen*, deals with the plight of a pregnant unmarried woman maltreated by her lover.

Art in the Service of Emancipation

The Hunted Slaves by Richard Ansdell, painted in 1861

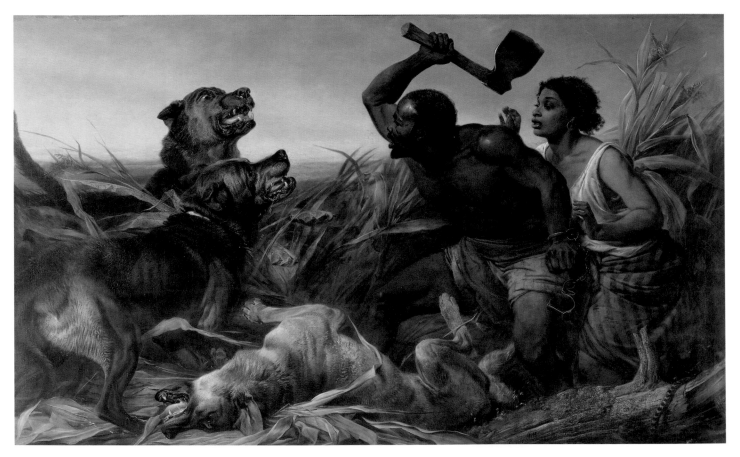

In dark fens of the dismal swamp
The hunted negro lay;
He saw the fire of the midnight camp,
And heard at times a horse's tramp,
And a bloodhound's distant bay.

Where hardly a human foot could pass,
Or a human heart would dare,
On the quaking turf of the green morass
He crouched in the rank and tangled grass,
Like a wild beast in his lair.

Extract from *The Dismal Swamp*
by Henry Wadsworth Longfellow

Slavery was abolished in Britain in 1807 but full emancipation of slaves in British territories was not achieved until 1834 and in France not until 1848. In September 1862 (the second year of the American Civil War), in his Emancipation Declaration, President Lincoln stated that from the following first of January 'all persons held as slaves within any State or designated part of a State the people whereof shall then be in rebellion against the United States shall be then, thenceforward, and forever free'. While slavery still persisted, the theme of the Fugitive Slave was to become an important one in art on both sides of the Atlantic.

Painted in 1861, the year of the outbreak of the American Civil War, this picture portrays two runaway slaves, turning at bay to face the pack of mastiffs which has pursued them into the wilderness. The man, darker-skinned than his partner, is depicted as a graceful, heroic and virile figure. The physical beauty of this man is rather like that of an ancient statue - such as the famous Roman statue of the Laocoon now in the Vatican Museums. The Civil War in America added topicality to the image of the struggle of slaves for freedom and life. When the painting was exhibited at the Royal Academy in 1861, the artist included in the catalogue a quotation from the poem *The Dismal Swamp* written in 1842 by the American poet Henry Wadsworth Longfellow (see opposite). Interestingly Longfellow's male slave is an old and pathetic figure quite unlike Ansdell's. Both Longfellow's poem and Ansdell's painting are powerful indictments of the savage treatment which black slaves suffered at the hands of their masters in the Southern states of the United States.

Abolitionist writings from the United States and Europe undoubtedly had an important impact on artists and writers. Harriet Beecher Stowe's *Uncle Tom's Cabin*, which had been inspired by the Fugitive Slave Act of 1850, won immediate popularity throughout Europe. A passage in this book describes how a slave named Scipio was cornered by a pack of dogs in a swamp. This may have been the inspiration for this picture. Harriet Beecher Stowe had even visited Liverpool in 1853, where she addressed meetings on the evils of slavery. Her liberal views were not well received. Liverpool was heavily dependent upon the importation of raw cotton from the Southern states and the export of finished goods. It was believed that slavery kept the price of raw cotton low, and its abolition could be expected to have a damaging effect upon the economy of north-west England. Indeed several Liverpool merchants enthusiastically supported the Southern Confederacy states. The Federal blockade of the Confederate ports during the American Civil War prevented the export of much cotton, upon which the Lancashire mills were dependent, leading to serious unemployment and hardship in the area. One of the most fascinating aspects of this painting's early history is that Ansdell donated it to the Lancashire Cotton Relief Committee, set up to relieve the suffering of mill workers. The Committee offered the painting as the prize in a lottery which raised about £700. The winner of the picture gave it to the Corporation of Liverpool.

The Noble Savage

Robinson Crusoe Explaining the Scriptures to Friday *by Alexander Fraser, painted about 1836*

This painting illustrates the episode in Daniel Defoe's novel *Robinson Crusoe*, first published in 1719, in which Crusoe explains the teaching of the Bible to his servant and companion, Friday. Friday is depicted in the novel as a subservient and almost childlike 'savage', an ignorant cannibal who is humanised, clothed, taught English and instructed in Christianity. Friday is a paradoxical figure. On the one hand he is suggestive of the stereotype of 'the noble savage' uncorrupted by the urbanity of European society, on the other he is presented as a receptive 'clean slate' capable of readily assimilating the morally superior teaching, brought from a supposedly racially superior culture.

Robinson Crusoe continued to be an extremely popular adventure story throughout the 19th century. This incident was painted by Fraser at the beginning of Victoria's reign - at a time of colonial expansion and growth of European missionary societies whose principal objectives included the baptism and conversion of Africans. It is precisely this kind of image that lent itself to being used as a lantern-slide illustration for a Sunday school lesson for children about Robinson Crusoe.

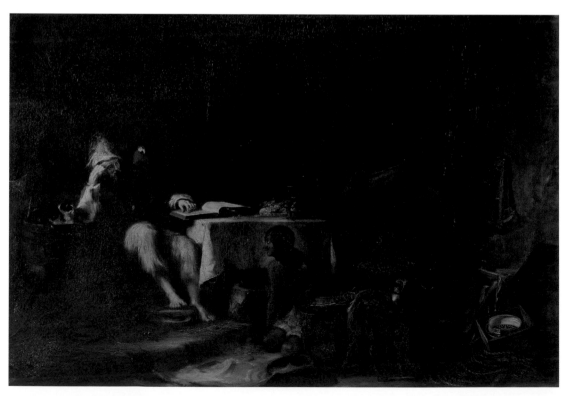

An Allegory of Oppression

The Court of Death by George Frederick Watts, painted in 1876

This allegorical subject about death was intended for use in a mortuary chapel. The winged figure on the throne is a personification of Death. In the preface of an exhibition catalogue of 1896 Watts wrote 'the soldier surrenders his sword, the noble his coronet, the mendicant and the oppressed seek relief.'

Watts made several versions of this picture. This version is the only one that features a black slave, representing 'the oppressed'. It suggests that his only way of escaping enslavement and repression is through death, which comes as a relief.

Slavery was abolished in America in 1863. The abolitionist movement promoted a stereotype of Blacks which persisted throughout the 19th century and into the 20th. The figure of the black slave kneeling, hands folded and eyes cast upward was perhaps the central icon of abolitionism, and whilst it humanised the image of the black man it also reinforced his status as victim.

Watts's own views on religion and social justice were complex. Early in his artistic life he painted pictures that dramatised the suffering of the poor. Several of his later paintings dealt in a didactic and allegorical way with the damaging effects of riches and luxury. He was essentially agnostic and wanted to paint subjects that were without reference to creed or dogma and that might act as spurs to conscience. It would thus be wrong to view Watts's Death in this picture as offering any supernatural succour or comfort to the enslaved.

Watts's own views on Africa were ambivalent. Whilst sympathising with the plight of slaves he nonetheless saw black people as life's natural underdogs and members of the 'less developed races'. This, he felt, justified British colonialism.

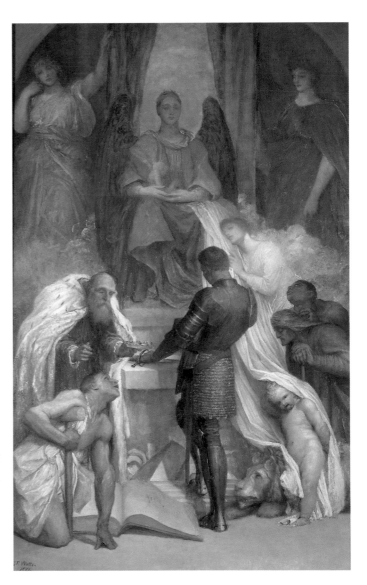

Images of Empire and Domination
The Flight of the Khalifa after His Defeat at the Battle of Omdurman by Robert Talbot Kelly, painted in 1899

What is termed the 'Scramble for Africa' - the race among European states to acquire territory in Africa - took place between 1880 and 1910, although European intervention in Africa had begun earlier. Colonialism was infused with nationalist and patriotic feelings and the idea of the warrior savage who would actively benefit from European dominance and interference grew in popularity.

In order to protect the Nile waters from French encroachment, General Kitchener had been ordered to invade the Sudan in 1897. This painting illustrates the Battle of Omdurman which took place on 2 September 1898 and which effectively terminated this Sudan campaign. Outside the city of Omdurman, Kitchener's combined Anglo-Egyptian army of about 26,000 men met those of the Khalifa Abd Allahi. Although his forces of between 50-60,000 men far out-numbered those of Kitchener, their simple weapons were no match for modern armaments. They were slaughtered by machine guns and artillery. This was followed up by an old-fashioned cavalry charge. The total losses of Khalifa Abd Allahi's men were about 10,000 killed, while the British suffered only about 500 casualties. Here we see a defeated army, mounted on horses and camels charging across the desert at great speed. The artist has included a number of women with young children among the retreating warriors as well as a mounted emir in ancient armour. This is a grossly romanticised vision of noble 'warrior savages', in flight from the battlefield. The inglorious nature of the British victory has been glossed over. Kelly spent a great deal of time in Morocco, Algiers and Egypt and specialised in Eastern subjects.

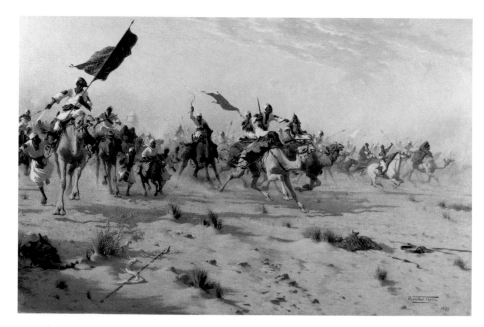

The Charge of the 21st Lancers at the Battle of Omdurman, by Richard Caton Woodville, painted in 1898

This painting depicts a separate incident during the Battle of Omdurman. The charge of the 21st Lancers was an attempt to cut off a large group of the Khalifa's men from the city of Omdurman at the end of the battle. The British had underestimated the size of this group which numbered about 2000. The Lancers were ambushed losing 70 men dead and wounded, the Khalifa's losses being far less. 320 men had fought against odds of at least seven to one and had held the field.

As the only incident in which the British had fought fairly and heroically with their opponents, it appealed to the British public who felt acute embarrassment about Omdurman. The rest of the battle had been more a case of mass extermination. Among the Khalifa's riflemen who are shown in this scene, there is an emir on horseback and the painting contains several portraits of Lancers who had eventually received awards for gallantry. Although there was in fact an emir recorded amongst the Khalifa's men, it is unlikely that he would have been dressed in the elaborate chain-mail that Woodville showed him wearing here. He looks more like a medieval Saracen Knight of the Crusades than a 19th century African warrior. By depicting this rather romantic view of hand-to-hand combat, the artist has attempted to heroicize an ignominious victory that owed much to the machine gun rather than to gallantry.

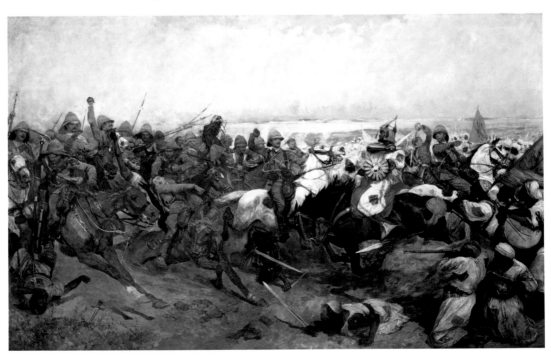

Orientalism

Le Mahboul by Auguste Bouchet, painted in 1877

Orientalism is a literary and artistic term referring to the exoticised depiction of the Near East by Western writers and artists, particularly in the 19th century. From the early 19th century, political events brought a rapid expansion of the West's contact with North Africa and the Middle East. Europeans travelled there seeking visual, religious and historical experience but also with the intention of transmitting to Europe, either in paint or the written word, a world characterised as strange, culturally remote and exotic, though increasingly accessible. By the late 1870s when this picture was painted, a number of richer Europeans were able to travel in comparative comfort on holiday tours to North Africa such as those organised by Thomas Cook who controlled the steamer business on the Nile. Pictures like this became popular as souvenirs.

This painting by the French artist Auguste Bouchet, was painted in 1877. Its title refers to a North African visionary, or Mahboul, the man seen playing the musical instrument. France had established colonies and trading interests in North Africa. Algeria, which was occupied in 1830, is the likely setting for the picture. The people of this region were ethnically Berbers and Arabs whose religion was Islam. Among Muslims, slavery persisted throughout the 19th century and Arab slave traders had brought black slaves from sub-Saharan Africa from at least Roman times. The painting shows a black, sub-Saharan African, playing music to a group of seated Arabs drinking coffee. Slaves who converted to Islam could be freed.

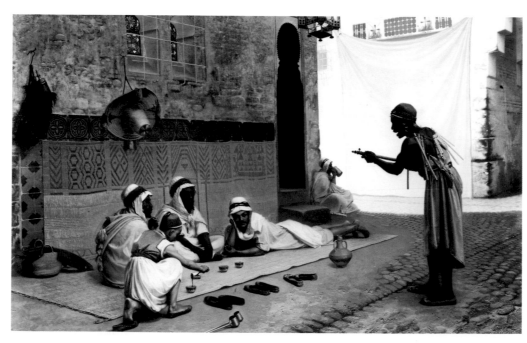

The Harem Slave

A *New Light in the Harem* by Frederick Goodall, painted about 1884

The Sultan's harem, in which a Muslim male kept his female dependants isolated from the world was, throughout the 18th and 19th centuries, one of the most tantalising subjects for European writers and artists. A group of women, sexually available only to one man, guarded by eunuchs and with the risk of death for any other man who should contact them was an alluring challenge to the imagination of many artists - especially as so few knew quite what a harem looked like. Several English and French artists made an erotic ideal of the subject, peopling their decorative interiors with languid half-naked women lying on divans or completely naked, being bathed singly or in groups by their handmaidens. Typically servants and slaves in these pictures are shown as black, reflecting the considerable number of African men and women who were enslaved in parts of the Muslim world. Goodall's picture is a distinctively domestic, sentimental and only mildly erotic treatment of the subject, designed to appeal to audiences who might have been embarrassed to contemplate more obvious nudity in a public art gallery. The mother of 'the new light' who might in reality have been an Arab woman is depicted here as an idealised pale-skinned European clad in a diaphanous dress.

Frederick Goodall (1822-1904) specialised in painting Eastern scenes and exhibited them over four decades at the Royal Academy. He visited Egypt in 1858 and 1870 and decried the growing commercialisation of Cairo and its tourist attractions. The European fantasy of the East required it to remain uncontaminated by the intrusion of the West whilst at the same time opening itself up to being painted, explored, documented and colonised - a paradox and a contradiction of ideals.

In reality slave nursemaids occupied an honoured position within the harem system and such woman were also sexual objects or concubines for the Sultan.

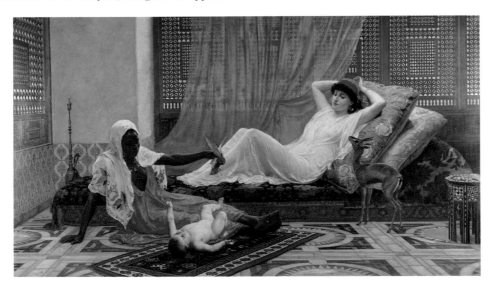

Late Colonial Exoticism
Two Jamaican Girls by Augustus John, painted in 1937

Between March and May in 1937 Augustus John visited Jamaica. There he painted a wonderful series of portraits of Jamaican women. Staying just outside Kingston, John persuaded the hotel servants and many other local girls to pose for him. Earlier in his career he had searched for the feminine exotic among Gypsies. These West Indian girls were in some ways a natural progression of this quest, although the style in which they are painted is quite different. John found it difficult to meet the Jamaicans and in his autobiography *Chiaroscuro* he says 'I was handicapped by my colour'. John wanted to be treated as an equal but found instead that he was taken for a visiting politician. This rather wounded his belief in his own bohemian sociability and capacity to get on well with all strata of society. His overall view of the Jamaicans seems to have been positive but he was bemused by what he saw as 'the famous Negro nonchalance'. Jamaica was a British colony and John observed how the white colonisers took little interest in the Jamaicans except as an inexhaustible supply of cheap labour. Sympathetic to their plight he stated, 'In my idle day-dreams I imagined myself heading an uprising of the Island, driving the whites, the good Governor and all, ... into the sea, and inaugurating a reign of Harmony in this potential Paradise.'

Whatever his motives, there is no doubt that Jamaica provided John with new subjects which gave him fresh inspiration. He was clearly fascinated by the richness and tonal subtleties he found there. 'Jamaicans show many shades of intermixture: their complexions are as various as their fruits, which they seem to imitate, assuming banana, apricot, citrus, paw-paw, mango or plum-like tints.'

The portraits, according to John, disappointed their sitters who had apparently expected to be given white skins. The paintings were well-received when exhibited at Tooth's Gallery, London, in May and June 1938 (from where the Walker acquired this portrait). The most celebratory review was that by the writer and painter Wyndham Lewis writing in the magazine *The Listener*,

'As one passes in review these blistered skins of young African belles, with their mournful doglike orbs, and twisted lips like a heavyweight pugilist, one comes nearer to the tragedy of this branch of the human race than one would in pictures more literary in intention, such as Gauguin would have supplied us with...'

John was undoubtedly influenced by the French painter Gauguin whose works he saw at Roger Fry's Post-Impressionist exhibition of 1910 and which included a large group of Tahitian pictures. Gauguin was seen as a man who had 'gone native' by rejecting western values in favour of a primitive and wild existence among the people of the tropical South Sea island of Tahiti. However whereas Gauguin's Tahitian figures fit the European stereotype of 'noble savages' whose lack of sexual inhibition epitomised the idea of a return to nature. John's two rather nervous young women are more convincingly, matter-of-fact. John probably only took a few hours to paint this picture and it has a lovely fresh and animated surface.

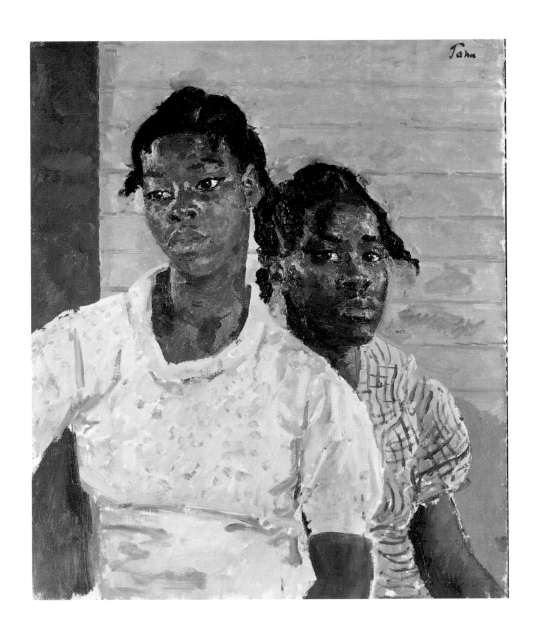

Suggested Reading

Albert Boime, *The Art of Exclusion: Representing Blacks in the Nineteenth Century*, Thames and Hudson, 1990

Gail Cameron and Stan Crooke, *Liverpool-Capital of the Slave Trade*, Picton Press, 1922

David Dabydeen, *Hogarth's Black: Images of Blacks in Eighteenth Century English Art*, Dangaroo Press, 1985

Jean Devisse, *The Image of the Black in Western Art*, Volume 2, *From the Early Christian Era to the Age of Discovery*, Harvard University Press, 1979

Peter Fryer, *Staying Power: The History of Black People in Britain*, Pluto Press, 1984

Hugh Honour, *The Image of the Black in Western Art*, Volume 4, *From the American Revolution to World War 1*, Harvard University Press, 1979

Paul HD Kaplan, *Titian's Laura Dianti and the origins of the motif of the black page in portraiture 1, 2 in Antichità viva*, XX/1 (Jan-Feb 1982) 11-18, XX1/4 (July-Aug 1982) 10-18

Reyahn King, Sukhdev Sandhu, James Walvin and Jane Girdham, *Ignatius Sancho: An African Man of Letters*, National Portrait Gallery, London, 1997

Jan Nederveen Pieterse, *White on Black: Images of Africa and Blacks in Western Popular Culture*, Yale University Press, 1992

William D Phillips, *Slavery from Roman Times to the Early Transatlantic Trade*, Manchester University Press, 1985

Anthony Tibbles (ed) *Transatlantic Slavery. Against Human Dignity*, for National Museums and Galleries on Merseyside, 1995

James Walvin, *The Black Presence: A Documentary History of the Negro in England*, Orbach and Chambers, 1971

James Walvin, *Black and White: The Negro and English Society 1555-1945*, 1973